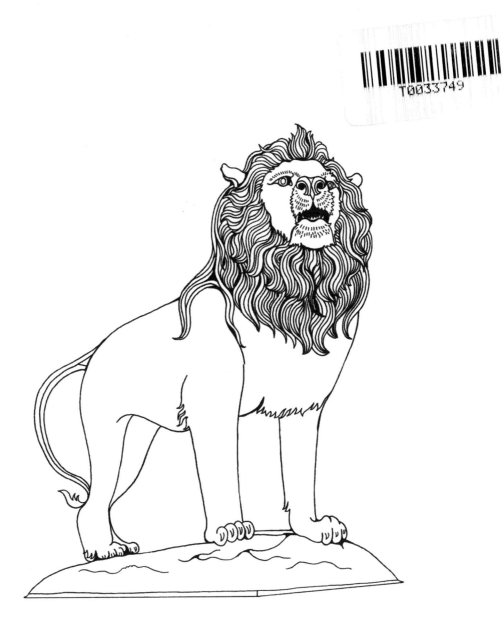

COLOR
CHICAGO

HARPER
DESIGN

An Imprint of HarperCollins Publishers

HarperCollins books may be purchased for educational, business, or sales promotional use. For information please email the Special Markets Department at SPsales@harpercollins.com.

Published in 2017 by
Harper Design
An Imprint of HarperCollins*Publishers*
195 Broadway
New York, NY 10007

Tel: (212) 207-7000 Fax: (855) 746-6023
harperdesign@harpercollins.com
www.hc.com

Distributed throughout the world in the English language by
HarperCollins Publishers
195 Broadway
New York, NY 10007

ISBN 978-0-06-257425-1

Printed in China

First Printing, June 2017

This book was conceived, designed, and produced by
Ivy Press
Ovest House, 58 West Street, Brighton BN1 2RA, UK

Ivy Press would like to thank the following for permission to reproduce copyright material:

Flamingo by Alexander Calder, 1974 © Calder Foundation, New York/DACS London 2016 (page 21), Crown Fountain by Jaume Plensa © DACS 2016 (page 29), and *Cloud Gate* by Anish Kapoor, 2004 © Anish Kapoor, All Rights Reserved, DACS 2016 (page 43).

All reasonable efforts have been made to trace copyright holders and to obtain their permission to create illustrations of copyright material. The publisher apologizes for any errors or omissions in the list above and will gratefully incorporate any corrections in future reprints if notified.

THIS BOOK BELONGS TO

...
...
...
...

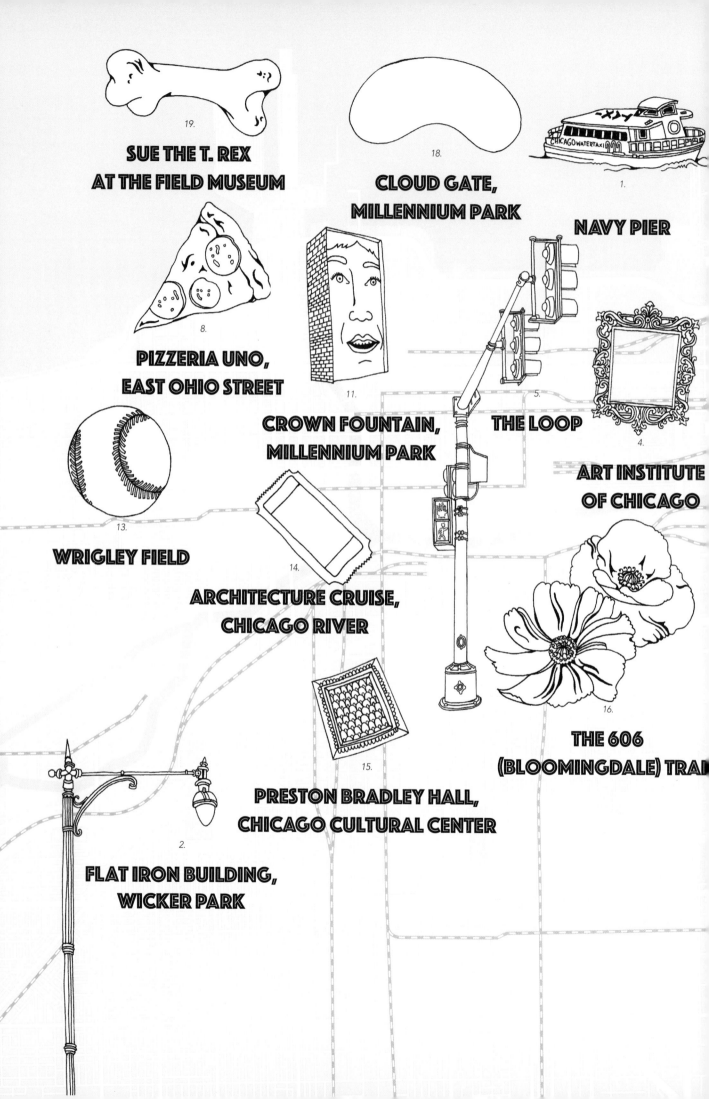

SUE THE T. REX
AT THE FIELD MUSEUM

19.

CLOUD GATE,
MILLENNIUM PARK

18.

NAVY PIER

1.

PIZZERIA UNO,
EAST OHIO STREET

8.

CROWN FOUNTAIN,
MILLENNIUM PARK

11.

THE LOOP

5.

ART INSTITUTE
OF CHICAGO

4.

WRIGLEY FIELD

13.

ARCHITECTURE CRUISE,
CHICAGO RIVER

14.

THE 606
(BLOOMINGDALE) TRAIL

16.

PRESTON BRADLEY HALL,
CHICAGO CULTURAL CENTER

15.

FLAT IRON BUILDING,
WICKER PARK

2.

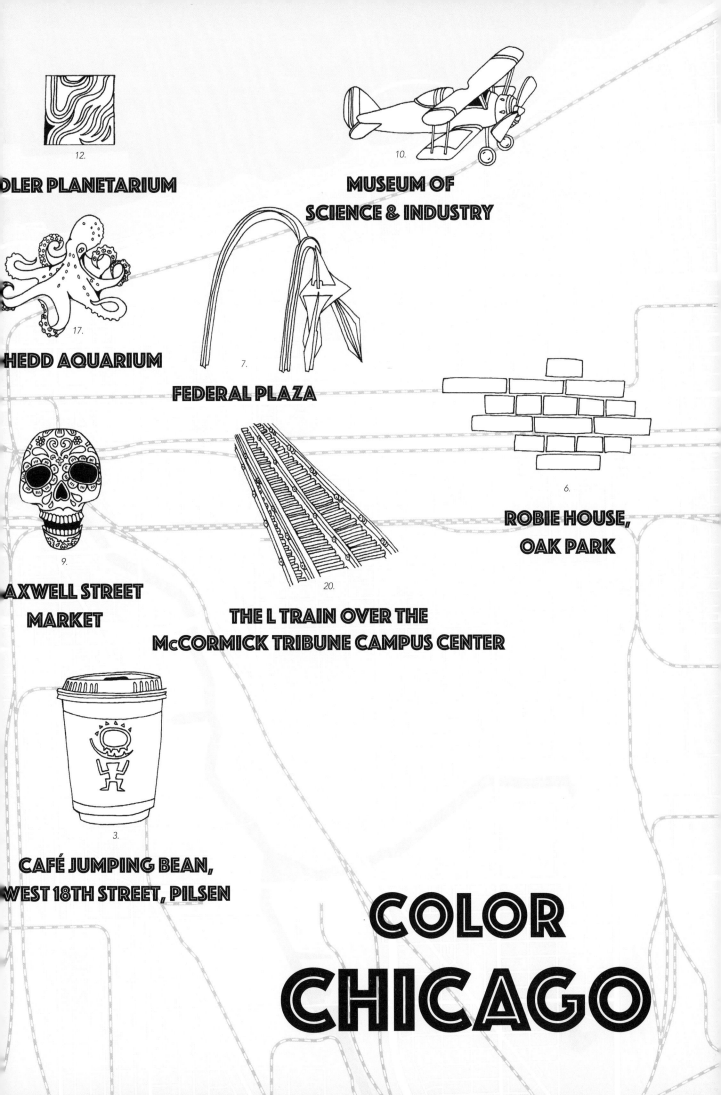

12.

DLER PLANETARIUM

10.

MUSEUM OF
SCIENCE & INDUSTRY

17.

HEDD AQUARIUM

7.

FEDERAL PLAZA

6.

ROBIE HOUSE,
OAK PARK

9.

AXWELL STREET
MARKET

20.

THE L TRAIN OVER THE
McCORMICK TRIBUNE CAMPUS CENTER

3.

CAFÉ JUMPING BEAN,
WEST 18TH STREET, PILSEN

COLOR
CHICAGO

INTRODUCTION

It's the third-largest city in the United States and has some of the most striking architecture anywhere in the world. Whether you like modern skyscrapers or Frank Lloyd Wright's much-vaunted Prairie School style, Chicago fills the bill. But there's more to this world-class city than its skyline. Chicago has its own green walkway, the 606, almost twice the length of New York's High Line and with just as much charm. The Field Museum displays the most complete *T. rex* skeleton on Earth—a dinosaur named Sue. Add in some of the greatest public spaces found in any modern city, which also feature some of the best public art, and you will find Chicago far from colorless.

Color Chicago offers twenty Chicago vistas, each with plenty of carefully recorded detail. Grab your colors and go on a virtual tour, from Navy Pier to Millennium Park and from Wrigley Field to the Adler Planetarium—you will find it all here. Nearly every scene is full of people, too, showing tourists mingling with native Chicagoans, who will show you how to get as much enjoyment out of their city as they do.

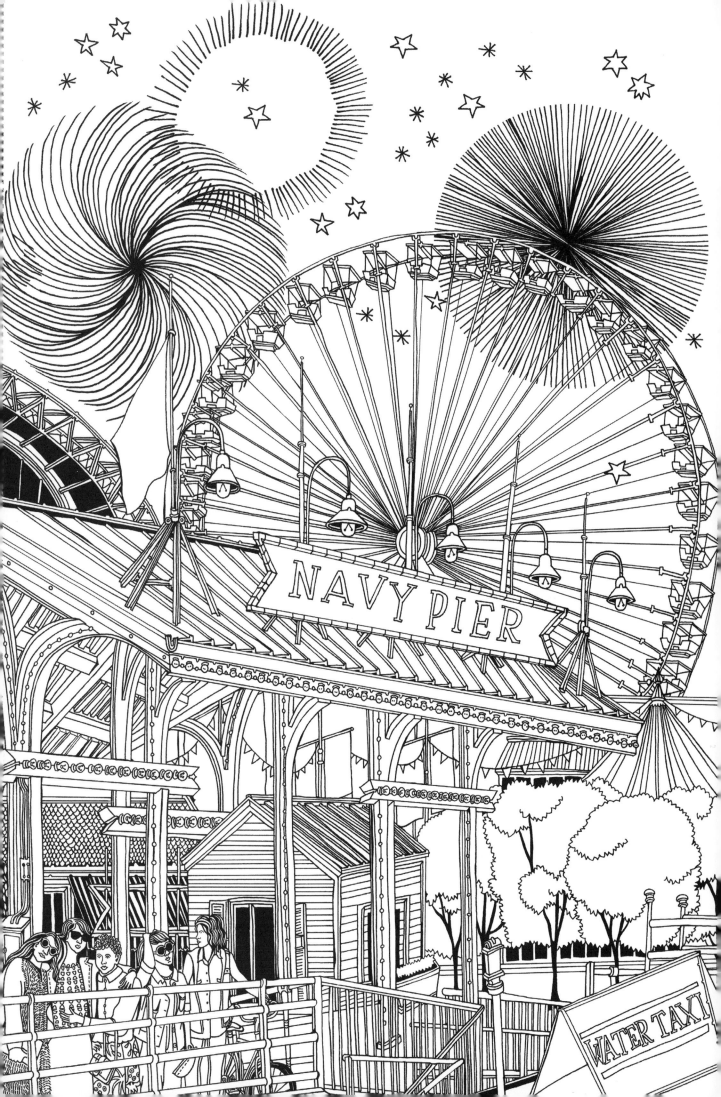

previous page

1.

NAVY PIER

Navy Pier hit its centenary on July 15, 2016. Reaching 3,300 feet (1,010 m) out over Lake Michigan, the pier has seen a lot of changes in its hundred-year history. Designed by Charles Sumner Frost as part of Daniel Burnham's grand plan for Chicago, it started as a dock for freight and passenger ships, with plenty of places for public entertainment, including a full-size theater. Later on, it served as a naval training center and hospital during World War II, and in the later 1940s as a site for university classes. Today it's an appealing mix of old and new elements—modern additions include a giant Ferris wheel that opened in 2016 and biweekly firework displays in summer.

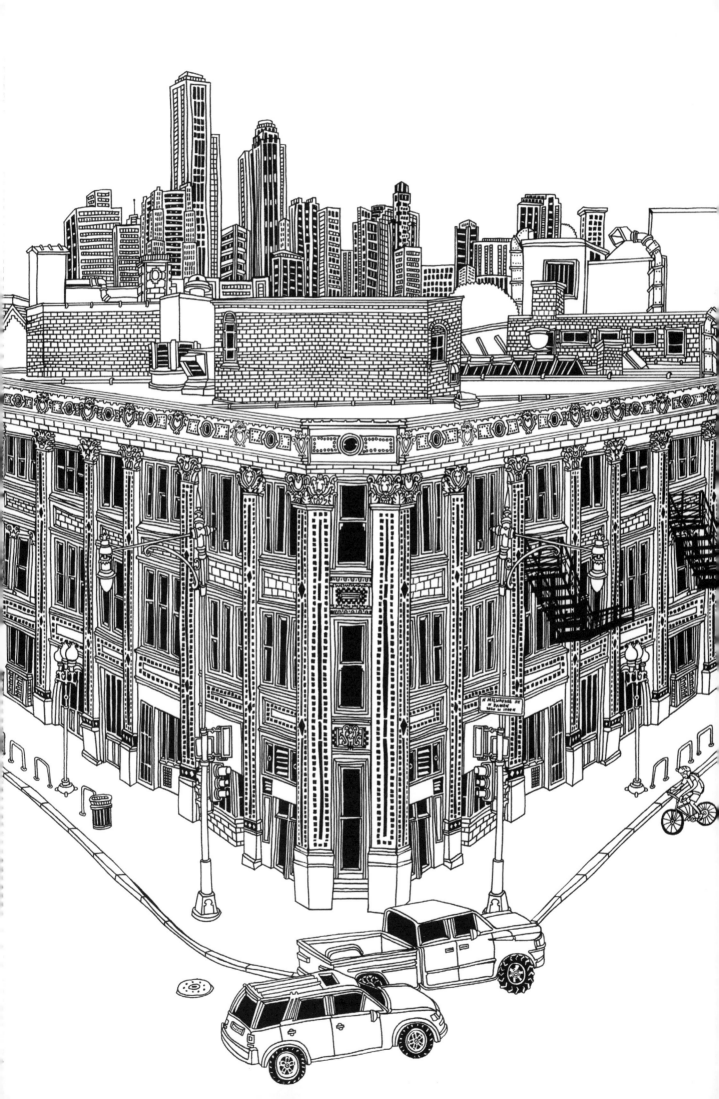

previous page

2.

FLAT IRON BUILDING, WICKER PARK

New York isn't the only city with a Flat Iron. Chicago's version may be only three stories high, but what it lacks in loftiness it more than makes up for in beautifully rendered architectural detail. Since it was built in 1913 by the then-stars of the Chicago School, William Holabird and Martin Roche, it has overseen many changes in its Wicker Park neighborhood from its corner spot at the intersection of North, Damen, and Milwaukee. By the 1980s the district was better known for its liquor stores and drug dealers than its cultural kudos, but the last three decades have reversed its fortunes, and the decorative masterpiece—now known as the Flat Iron Arts Building— today houses studios, performance art, music recitals, and a host of artists under its historic roof.

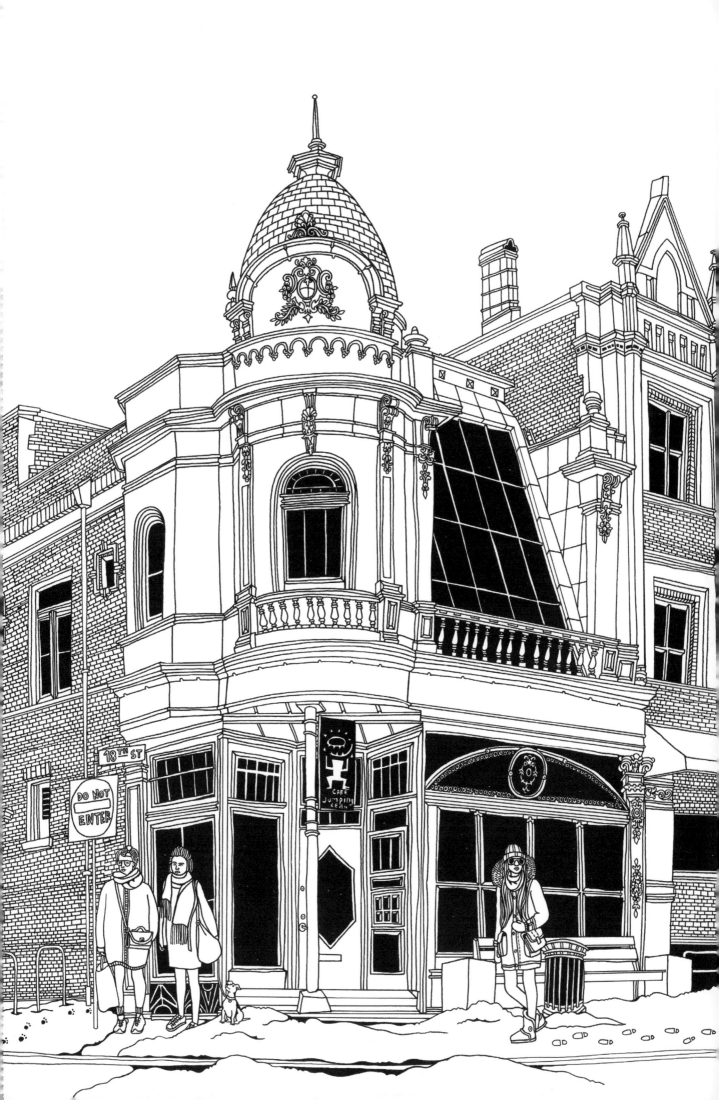

previous page

3.

CAFÉ JUMPING BEAN, WEST 18TH STREET, PILSEN

In the late nineteenth century, the Pilsen neighborhood was settled by a lively mix of Czech, Slovak, Irish, German, and Austrian immigrants, ranging from professionals to the workers who staffed the local factories. Gradually the Latino and Hispanic populations in the area also grew, creating a true melting pot in Chicago's Lower West Side. Today, Pilsen is known for the murals that decorate many of its buildings' facades, for its world-class National Museum of Mexican Art, and for its dozens of lively taquerias, restaurants, local bars, and cafés. Typical of the vibrant small independent businesses of the area, Café Jumping Bean has clocked in more than two decades on its corner at West 18th Street.

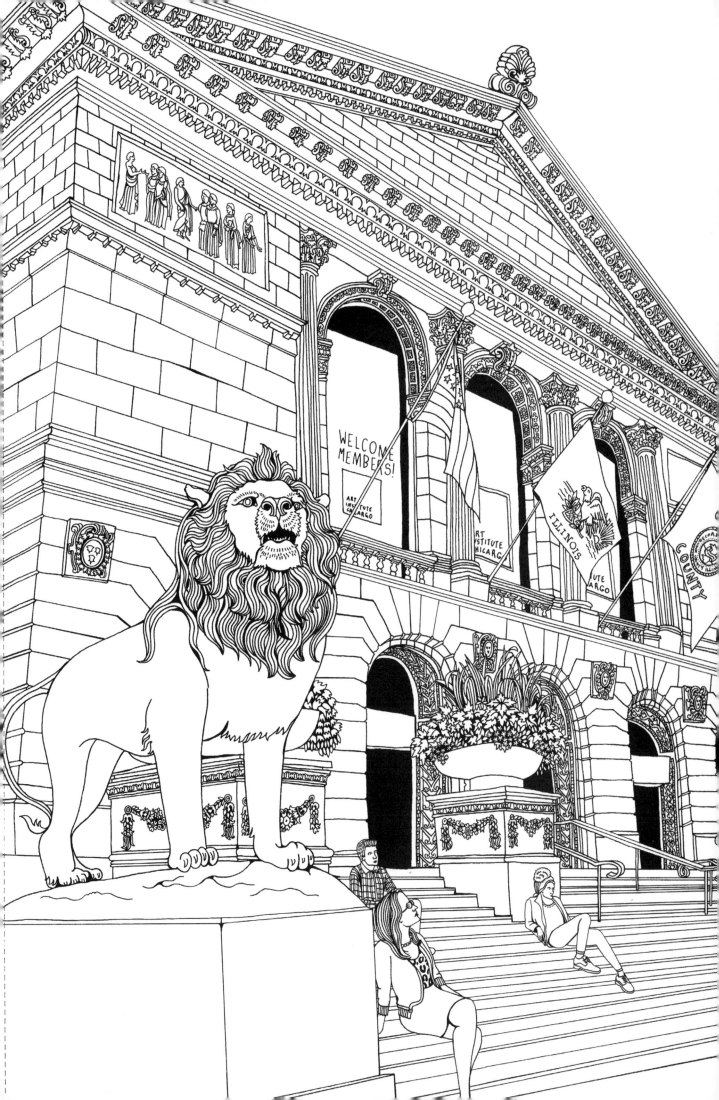

previous page

4.

ART INSTITUTE OF CHICAGO

The lions standing on guard beside the steps of Chicago's Art Institute arrived there in 1894—the same year that the building became the go-to home for the city's incomparable collection of art. Cast in bronze and weighing more than two tons each, they were modeled by the popular contemporary animal sculptor Edward Kemys, who gave each lion its own personality: the one on the south pedestal stands, in his words, "in an attitude of defiance," while its twin, perched on the north pedestal (shown in the picture), is "on the prowl." Behind the building's classical facade, multiple collections give visitors a rich experience, offering works as varied as Benin bronzes, art nouveau furniture, and paintings from American greats such as Edward Hopper, Georgia O'Keeffe, and Winslow Homer.

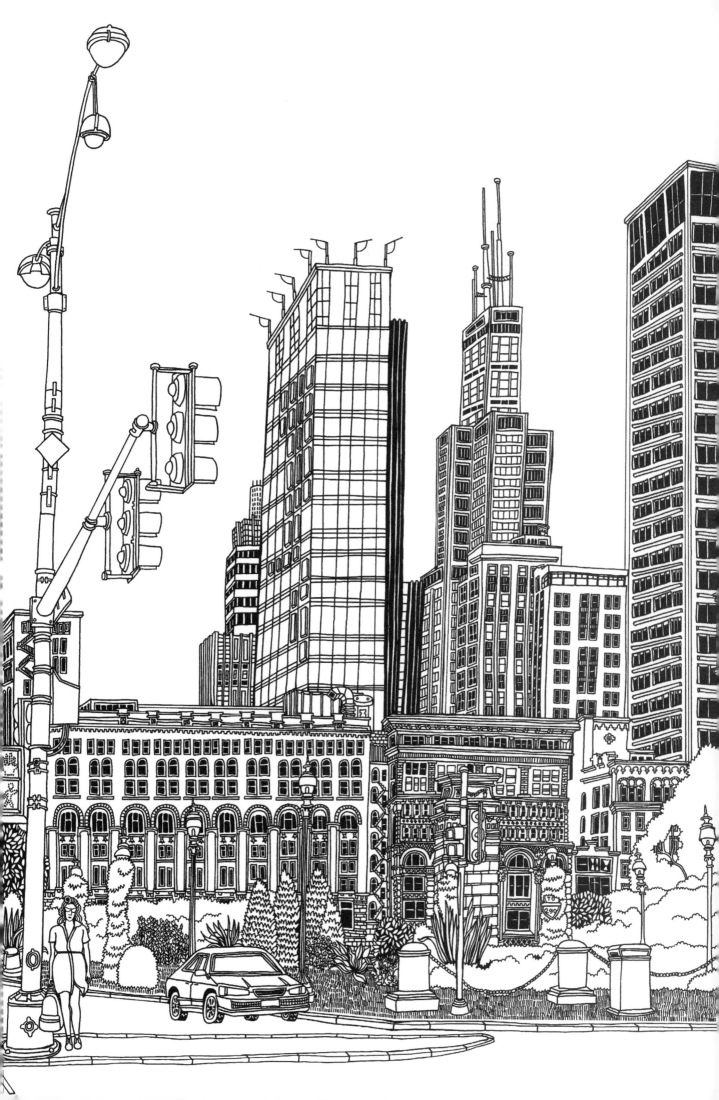

previous page

5.

THE LOOP

This central-east area of Chicago has been known as the Loop for more than a century—theories on why abound, although it was probably named for the loop that the cable cars made here as they swapped directions. Today, it's the main business area of the city, and the location of many of its best-known skyscrapers, including the Willis (originally Sears) Tower, which stands higher than the other buildings in the picture and was the tallest building in the world, at 108 stories, when it was completed in 1973. Its considerably shorter brother, the forty-four-story CNA Center—the blocky building on the right of the picture—gained its striking ochre-red appearance when it was painted by one of its original tenants.

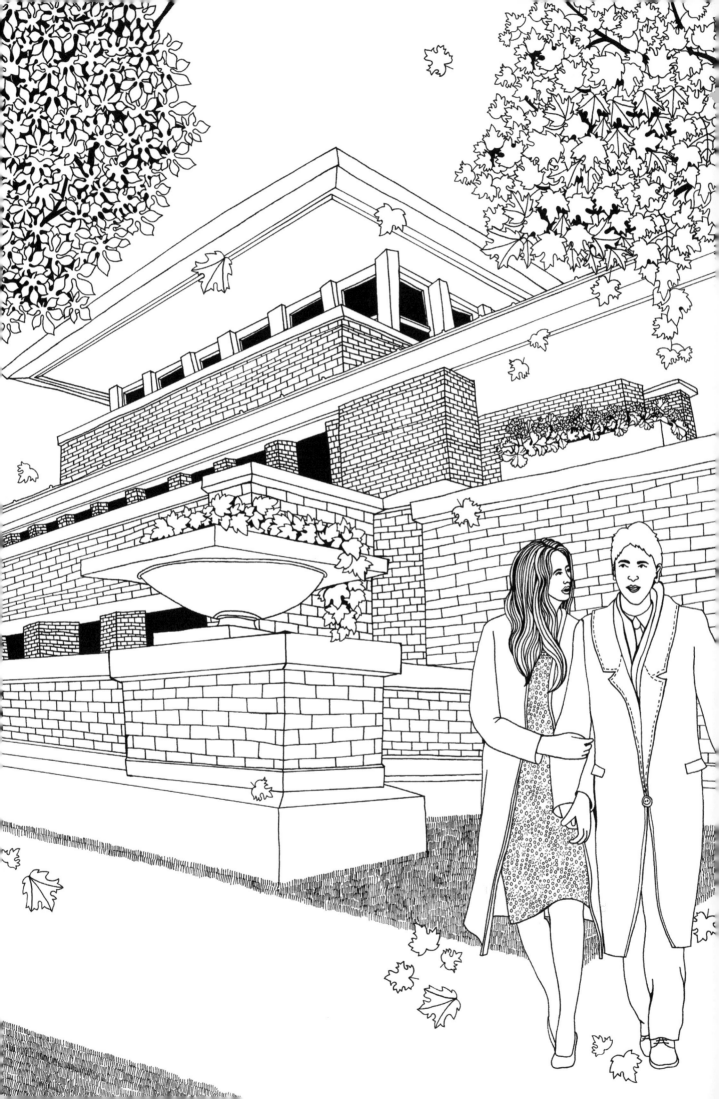

previous page

6.

ROBIE HOUSE, OAK PARK

For architectural enthusiasts, Chicago has a unique draw: the city has the highest concentration of Frank Lloyd Wright's celebrated Prairie School buildings than anywhere in the world. The jewel in the crown is the Robie House on South Woodlawn Avenue in Oak Park. Completed on commission in 1910 and registered as a Historic Landmark by 1963, the house still has its original interior decor and many of its furnishings. Like other Prairie School architecture, it embraces simplicity, function, and handcrafting. Today it's open to the public between Thursday and Monday, and thousands of visitors have enjoyed its atmospheric spaces (and its immaculate state of preservation).

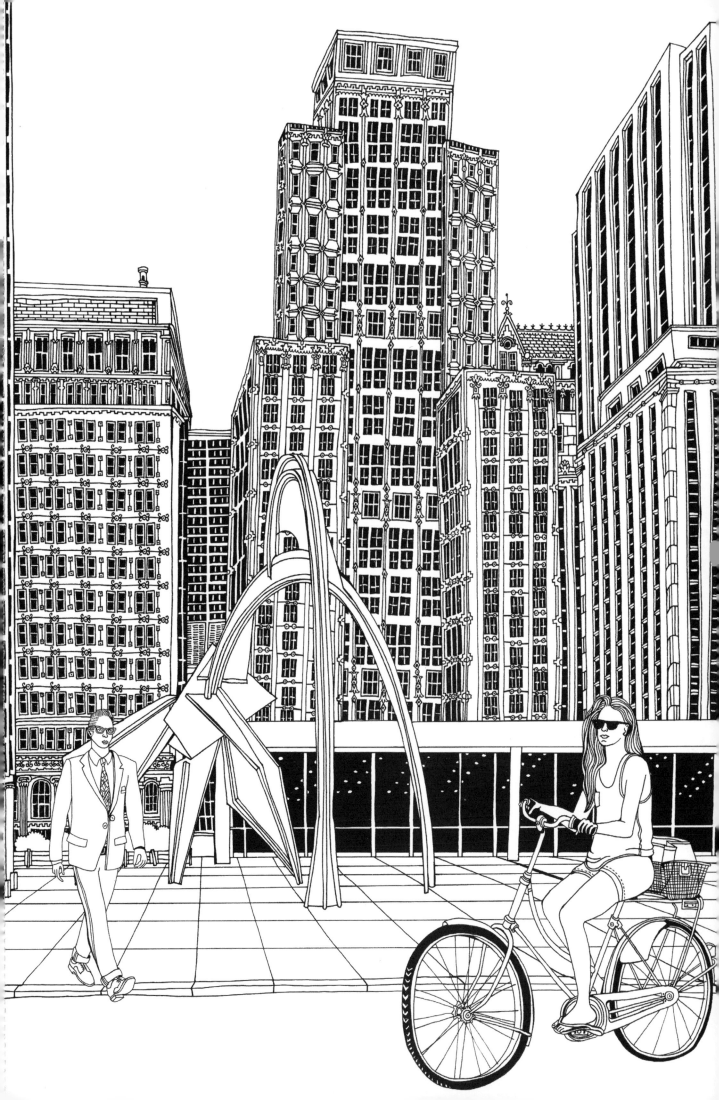

previous page

7.

FEDERAL PLAZA

Whether it's architecture or art that appeals, Federal Plaza, at the heart of the Loop, has plenty to offer: three Ludwig Mies van der Rohe steel-and-glass masterpieces, plus one truly impressive Alexander Calder sculpture, *Flamingo*. Opening to South Dearborn Street on one side, the plaza is an ideal showcase for Mies van der Rohe at his blocky, Modernist best, while the brilliantly orange-red carbon-steel *Flamingo* offers a focal point for the plaza without taking up too much ground space. It's one of the Loop's most-used open spaces, home to a regular farmer's market, and hosting plenty of outdoors political and cultural gatherings.

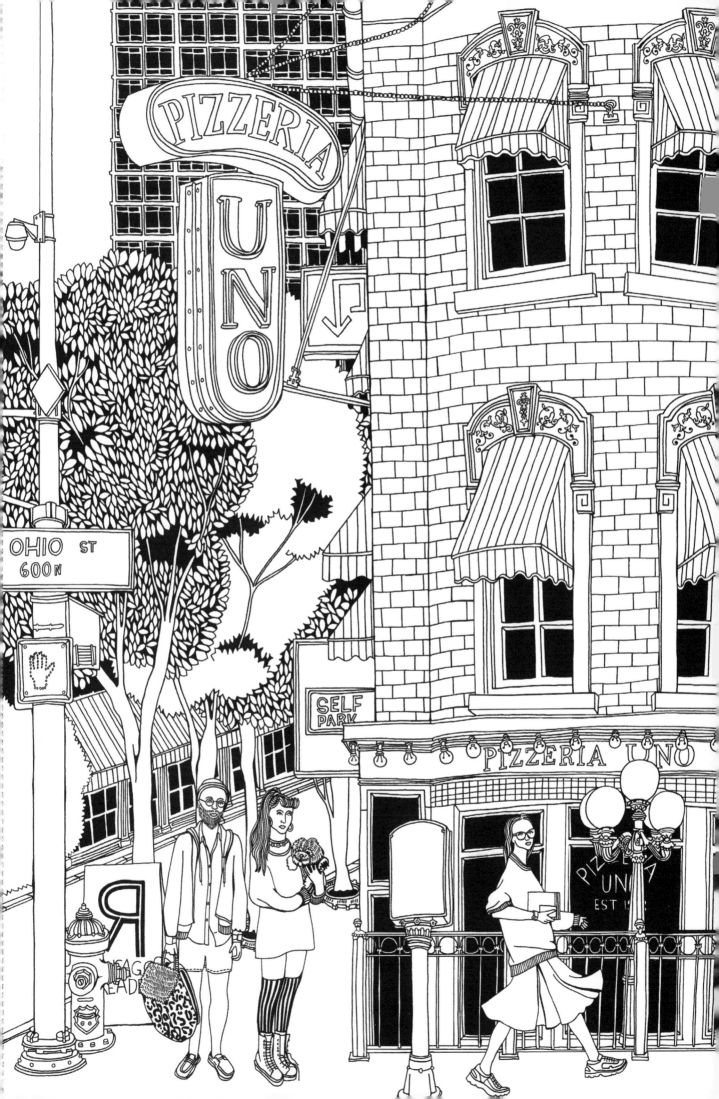

previous page

8.

PIZZERIA UNO, EAST OHIO STREET

Deep-dish pizza is a Chicago institution, and no one serves up the classic pie better than Pizzeria Uno, which has been feeding loyal locals and keen pizza pilgrims from its downtown spot at the corner of North Wabash Avenue and East Ohio Street since 1943. Tradition holds that Ike Sewell, Uno's entrepreneurial original owner, was struck by an inspiration: he'd combine classic pizza toppings with a deep, buttery crust more like that of a pie. Baked for a full hour, the result soon gained a loyal following, and although today there are other branches scattered over more than twenty states, the line at East Ohio Street testifies that Pizzeria Uno will always be the first and best.

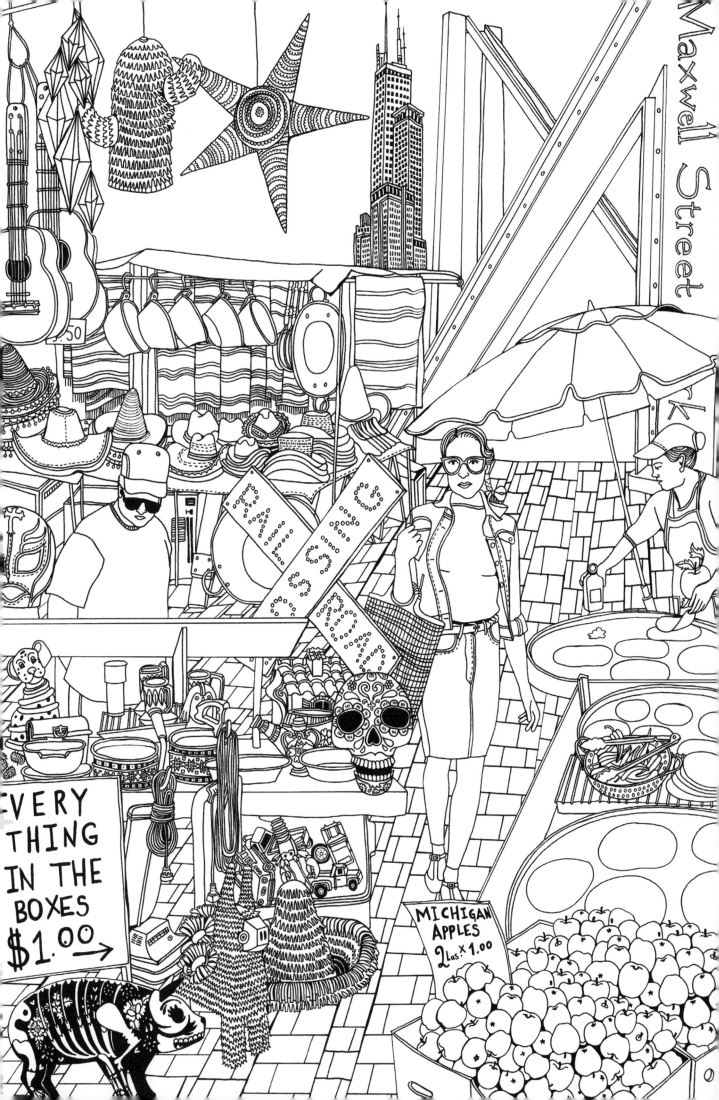

Maxwell Street

MUSIC

EVERY
THING
IN THE
BOXES
$1.00 →

MICHIGAN
APPLES
2 Lbs. X 1.00

previous page

9.

MAXWELL STREET MARKET

In the late nineteenth century, a small produce market opened on Maxwell Street, run by and for recent immigrants who were more at home with the give-and-take bargaining at their local stalls than they were in Chicago's more formal stores. In its early days the market's trade was mainly in food and used clothes, leavened with a few street entertainers and eccentrics, such as the Chicken Man with his performing rooster. Over time, the market has morphed and moved—it's had several locations over the last century, and its current incarnation is on South Desplaines in the South Loop. It's still a treasure-house for bargain hunters, offering a vast range of goods, from cheap plastic bowls to fancy piñatas, every kind of garment, and plenty of fresh produce and street food too.

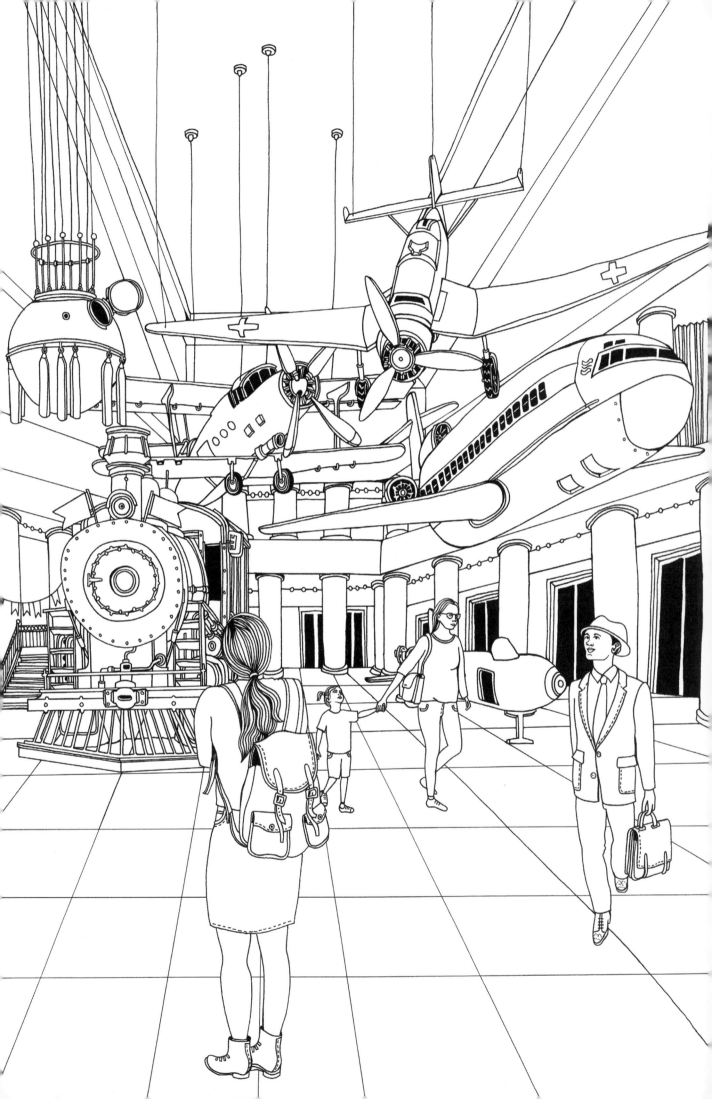

previous page

10.

MUSEUM OF SCIENCE & INDUSTRY

Located in Jackson Park in an imposing building originally built for the World's Columbian Exposition in 1893, the Museum of Science and Industry is one of the world's largest science museums. The Transportation Hall houses some of its most jaw-dropping exhibits, from a Boeing 727 suspended from the ceiling, which you can actually walk inside, to a replica of the Wright brothers' 1903 Flyer, plus the first locomotive to reach a speed of 100 mph— all guaranteed to thrill even the most jaded or screen-addicted child. It's pretty cool for adults too.

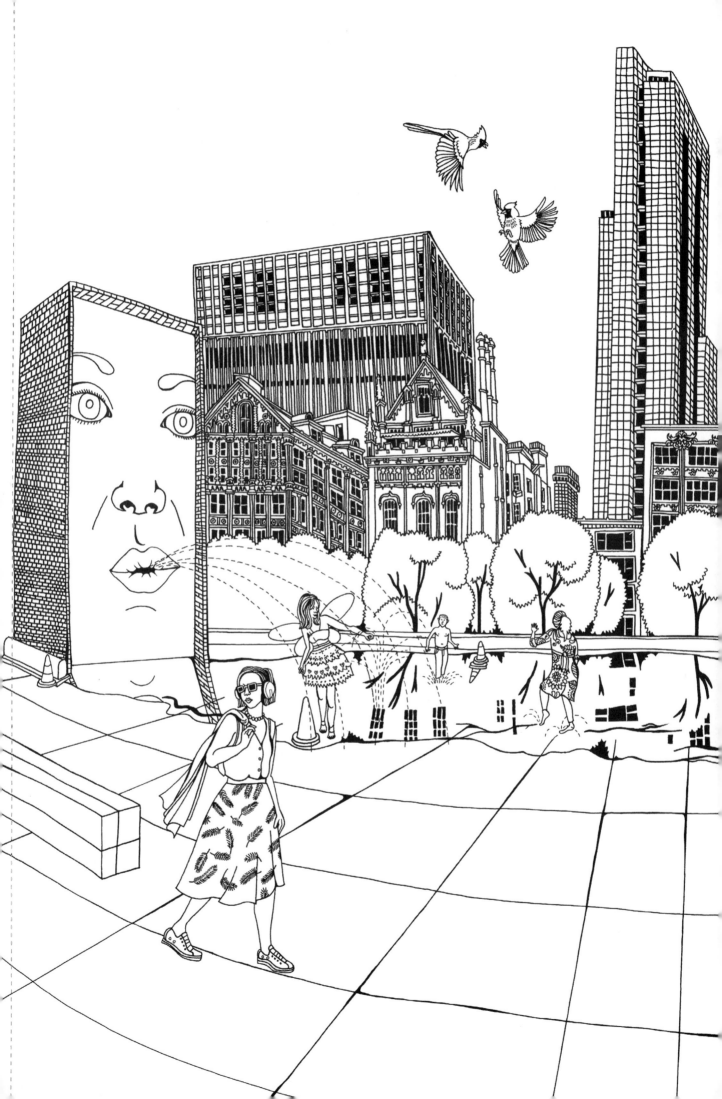

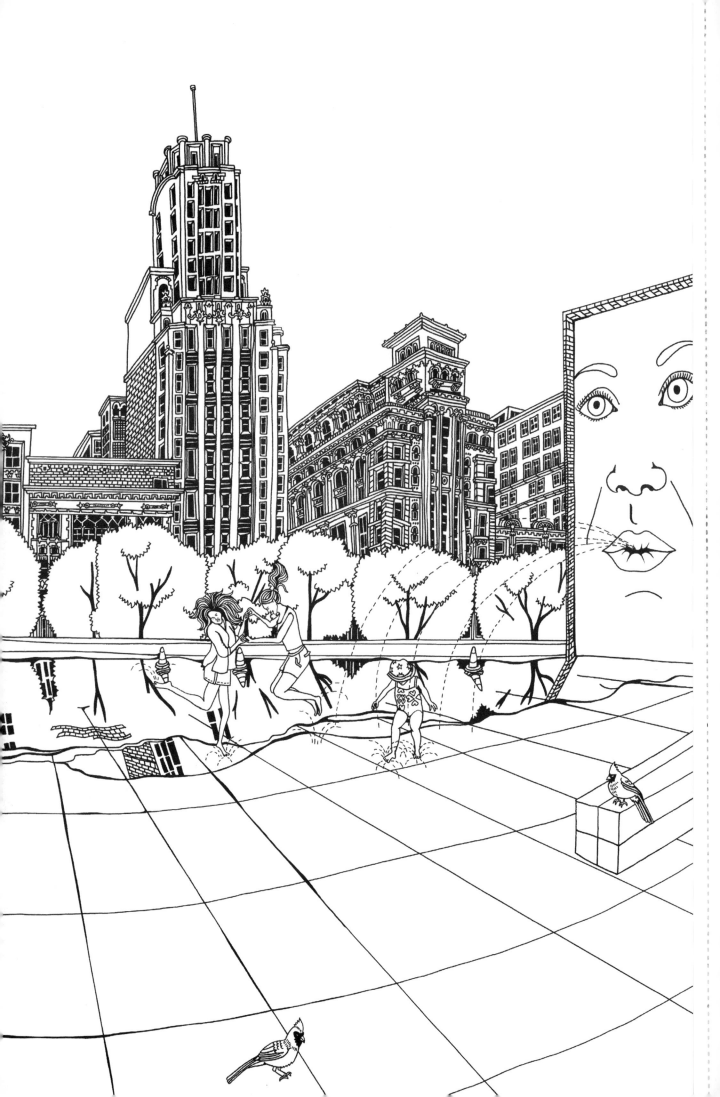

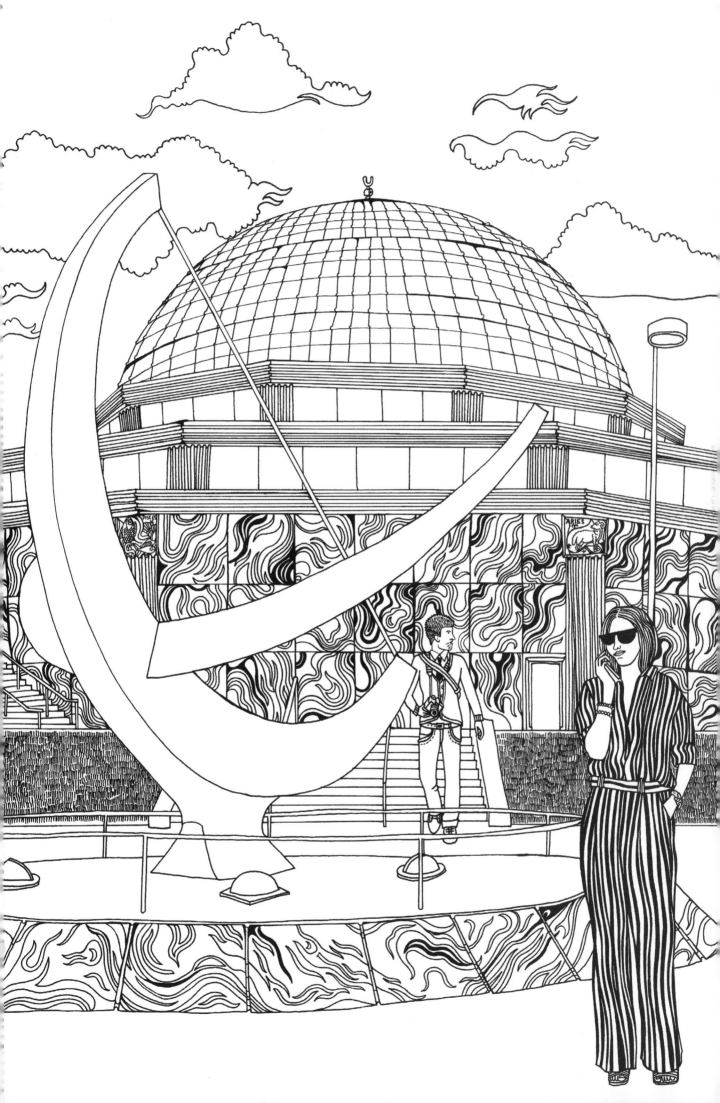

previous page

12.

ADLER PLANETARIUM

When local businessman and philanthropist Max Adler first heard
of the idea of projecting sky maps onto the inner surface of a dome—
a new idea in the 1920s—he was determined to bring Chicago one
of these new "planetariums." In 1930 the Adler Planetarium (the first
in the United States) opened on the tip of Northerly Island, the only
"leisure island" ever built of five originally planned by Daniel Burnham
back in 1909. The planetarium's original dome is still at the center
of the complex, together with *Man Enters the Cosmos*, the sundial
sculpture by Henry Moore that has stood in its forecourt since 1980,
but since then the planetarium has been much augmented, and now
includes one of the biggest collections of telescopes anywhere,
plus the cutting-edge Doane Observatory for hands-on stargazing.

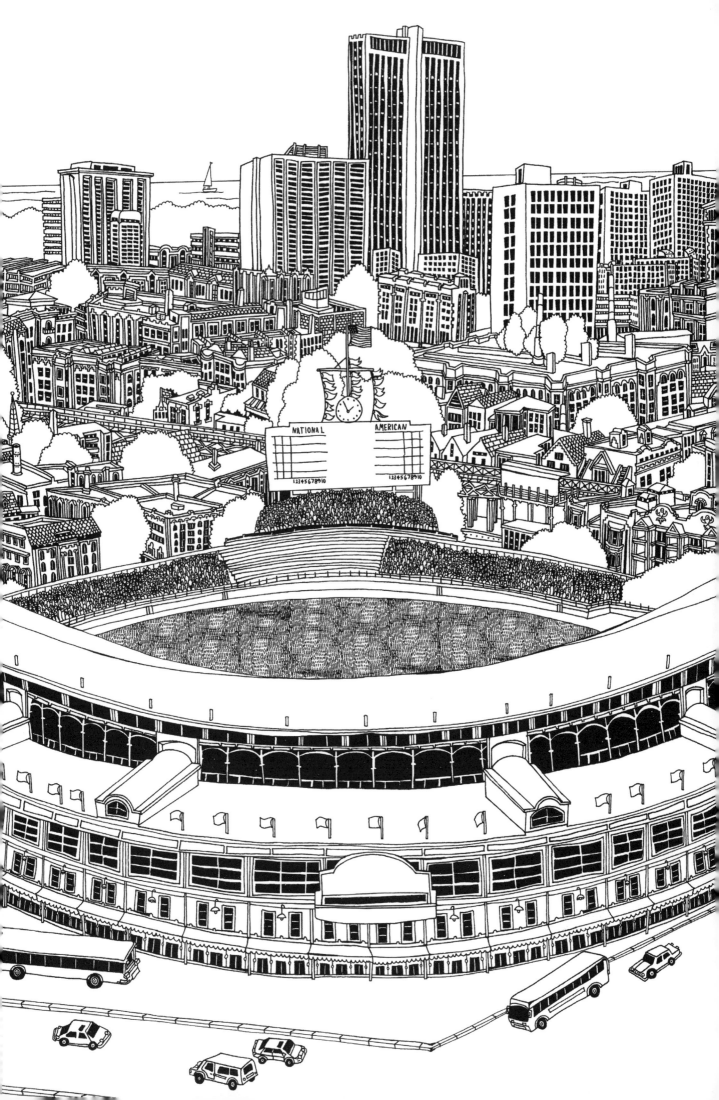

previous page

13.

WRIGLEY FIELD

Named in 1926 for the chewing-gum magnate who had bought the home team, the Chicago Cubs, for half a million dollars, Wrigley Field is as much a Chicago institution as Prairie School architecture and deep-dish pizza. Baseball enthusiasts can tick off its iconic features one by one: the ivy-covered outfield wall, the vintage hand-turned scoreboard, and—outside the stadium—the famous red marquee with its art deco-style lettering, highlighted with neon accents after dark. All will induce instant recognition in every sports lover.

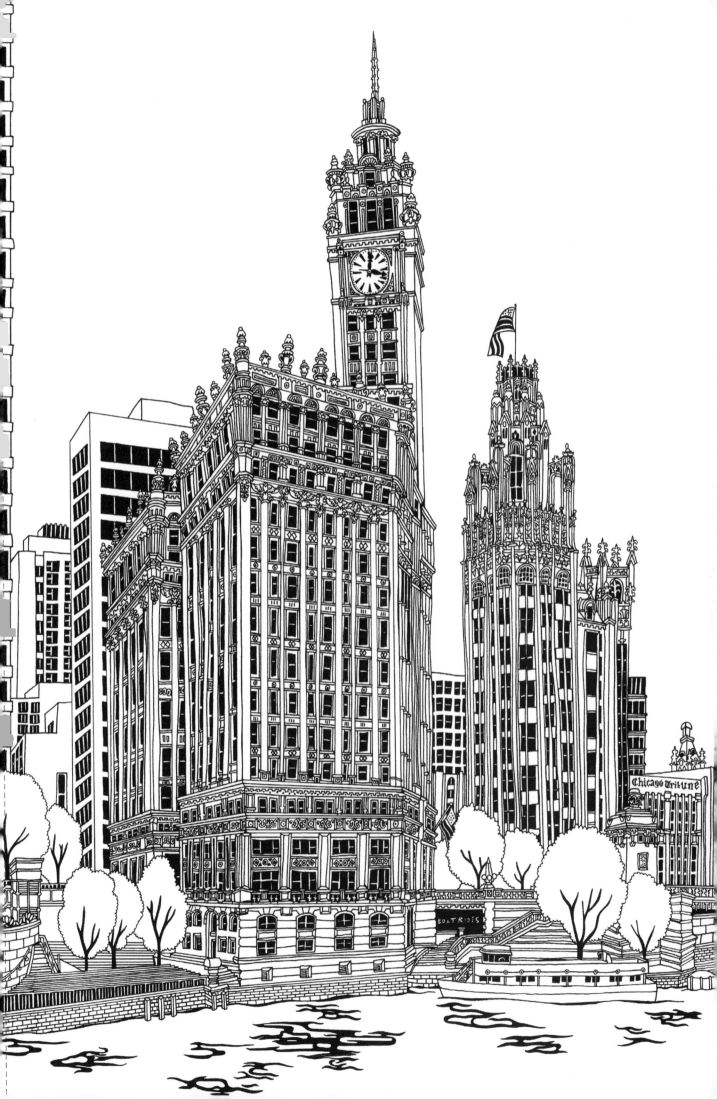

previous page

14.

ARCHITECTURE CRUISE, CHICAGO RIVER

A boat ride along the Chicago River gives you some insight into how the Great Fire of Chicago in 1871 changed the face of the city—chugging along at water level, you can clearly see the strata of different building styles that have gone up since. On the left of the picture is the Wrigley Building, completed in 1924 as headquarters for the Wrigley chewing-gum empire, and on the right is the 1925 Tribune Tower, home to the *Chicago Tribune*. A neo-Gothic masterpiece, the Tribune Tower is worth a look up-close; its lower stories are inset with labeled stones and rocks brought from famous sites all over the world, from the Parthenon to the Taj Mahal—a conceit of the *Tribune*'s owner Robert "Colonel" McCormick.

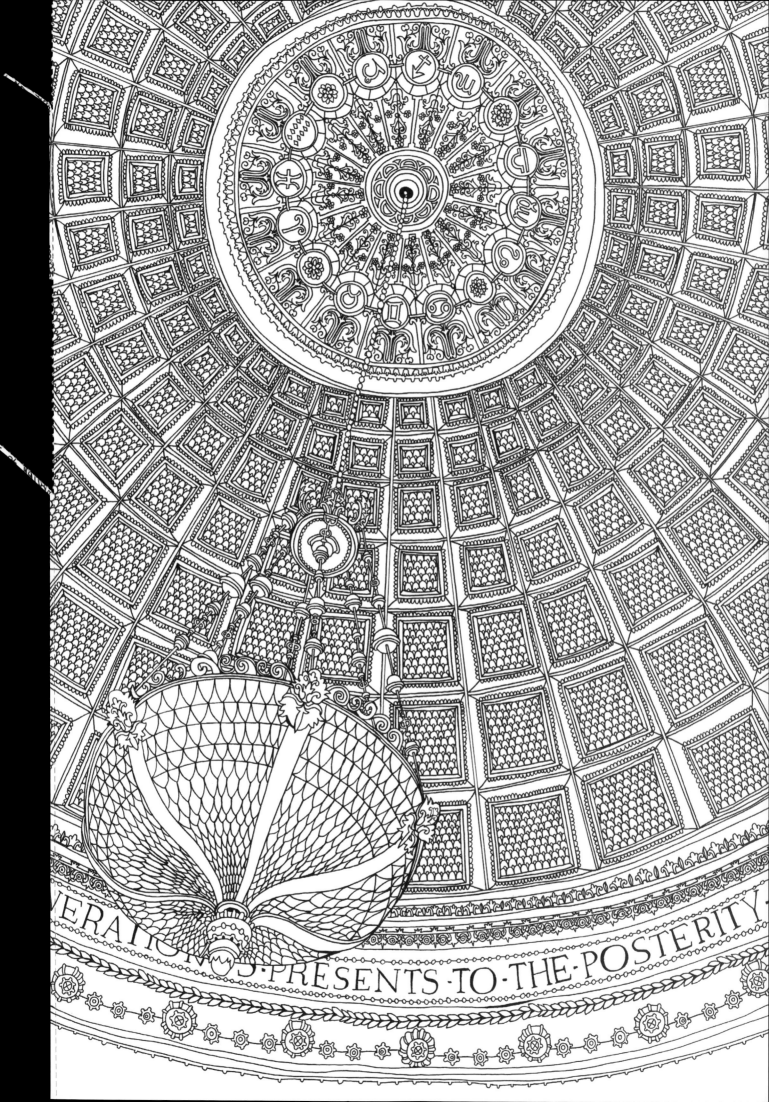

previous page

15.

PRESTON BRADLEY HALL,
CHICAGO CULTURAL CENTER

From the outside, Chicago's Cultural Center, opened in 1897, offers a calm, neoclassical face to East Washington Street, elegant and imposing but hardly electrifying. Step inside, however, to see an altogether more ornamented vision, encompassing a Carrara marble lobby, mother-of-pearl mosaics, and perhaps the building's high point—the stained-glass dome of Preston Bradley Hall, one of the center's showpieces. At thirty-eight feet (over 11.5 m) in diameter, it's the largest Tiffany dome in existence, containing 30,000 pieces of glass in a fish-scale pattern, all held within a cast-iron frame. The fish-scale motif is echoed in the shade of the massive hanging light, and the signs of the zodiac at the apex of the dome offer a final elaborate touch. Look upward and gasp.

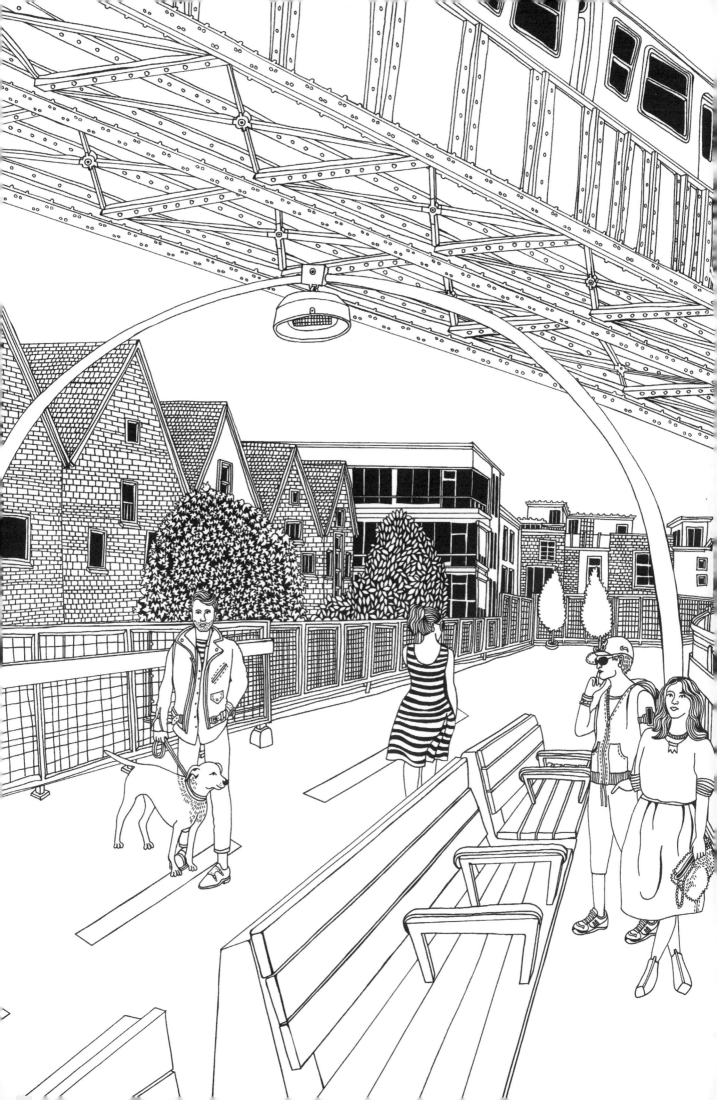

previous page

16.

THE 606 (BLOOMINGDALE) TRAIL

A path, a park, and a city resource all in one, the 606 may not (yet) have reached the international acclaim of New York's High Line, but it has just as much appeal and, at nearly three miles (4.3 km), it's almost twice as long. The walkway, which runs above the city streets from Humboldt Park to the skateboard park in Logan Square, was created on the old Bloomingdale Line, a section of Chicago's elevated railway tracks that fell into disuse in the 1990s. At first the 606 was a local secret, quietly accessed and enjoyed, but left to grow wild. A regeneration program began in 2004, and the trail was paved, planted, and generally neatened up and enhanced, before being officially opened in 2015.

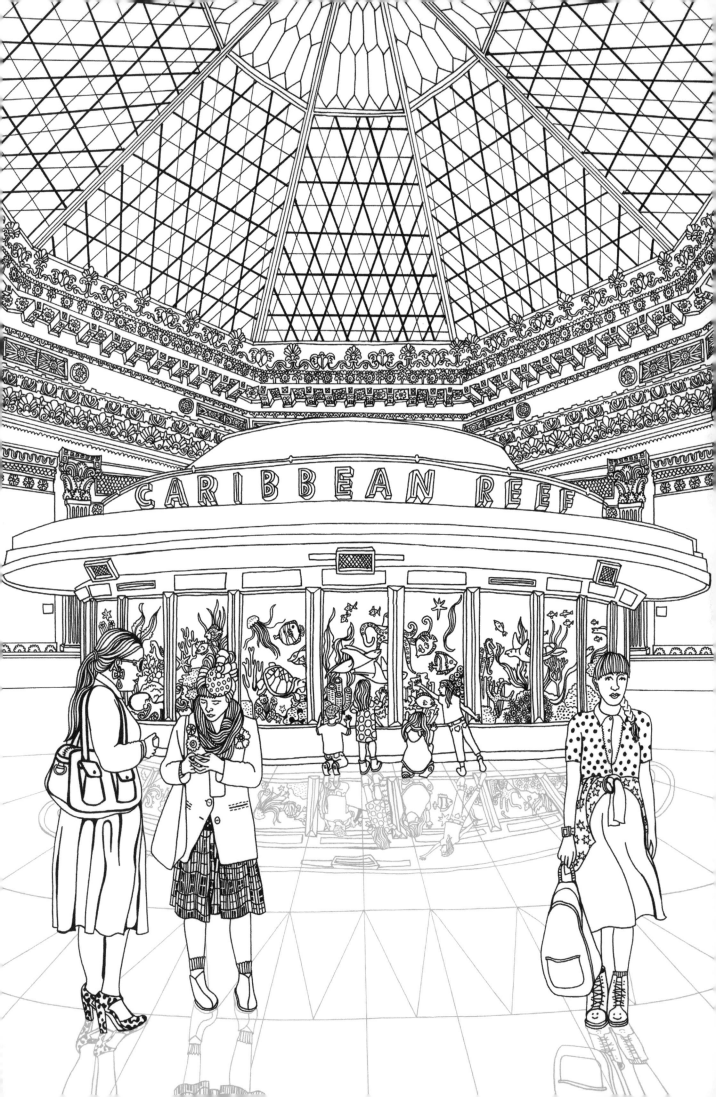

previous page

17.

SHEDD AQUARIUM

Chicago likes its attractions large, and the Shedd Aquarium,
located close to both the Adler Planetarium and the Field Museum,
is no exception. Its proud boast is that it houses more than 32,000
animals, from river turtles and sea otters to stingrays and seahorses.
Opened in 1930, it has been innovating ever since; one of its most
popular exhibits is the circular Caribbean Reef tank, introduced in
1971, which contains—as you'd guess—a complete reef-in-a-box
which visitors can walk around and watch the wildlife going about
its everyday business.

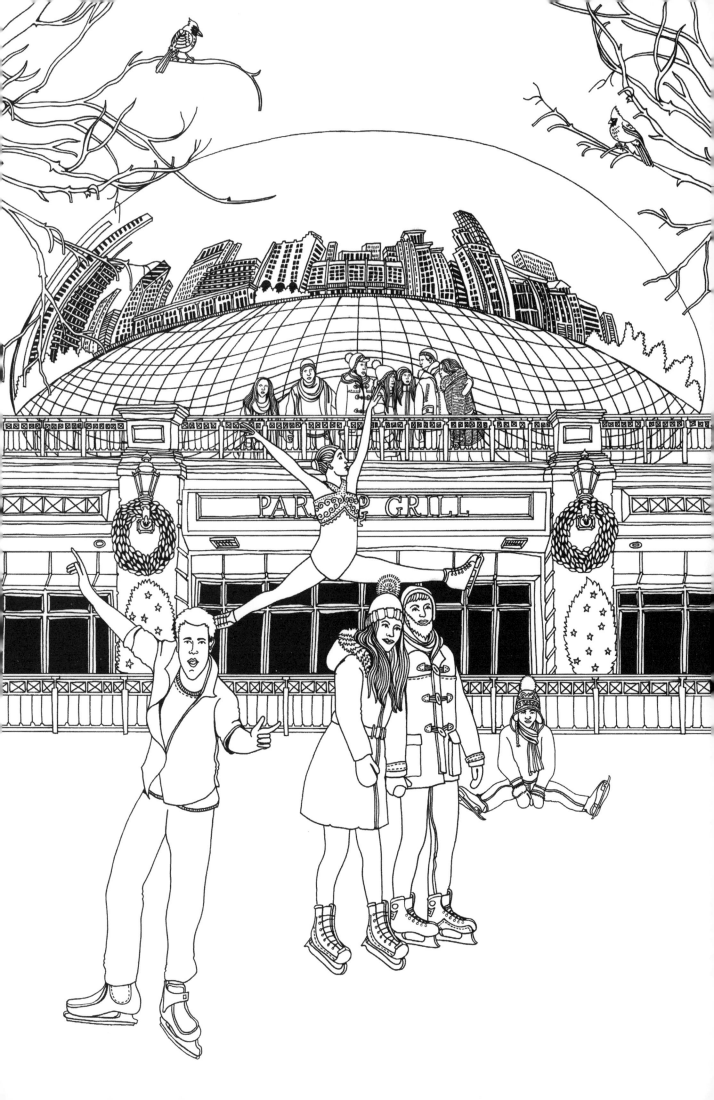

previous page

18.

CLOUD GATE,
MILLENNIUM PARK

Cloud Gate, the gleaming stainless-steel sculpture at the center
of the AT&T Plaza in Millennium Park, has been known as "the Bean"
to Chicagoans almost from the moment it was completed in 2004.
Created by the British sculptor Anish Kapoor, its distorted reflections
of the skyline around it are endlessly engaging, as is its curved vision of
the sky and clouds passing overhead. Visit between mid-November
and mid-March and there's the additional attraction of an outdoor
skating rink on the lower level of McCormick Tribune Plaza: you can
watch the changing reflections as you skate.

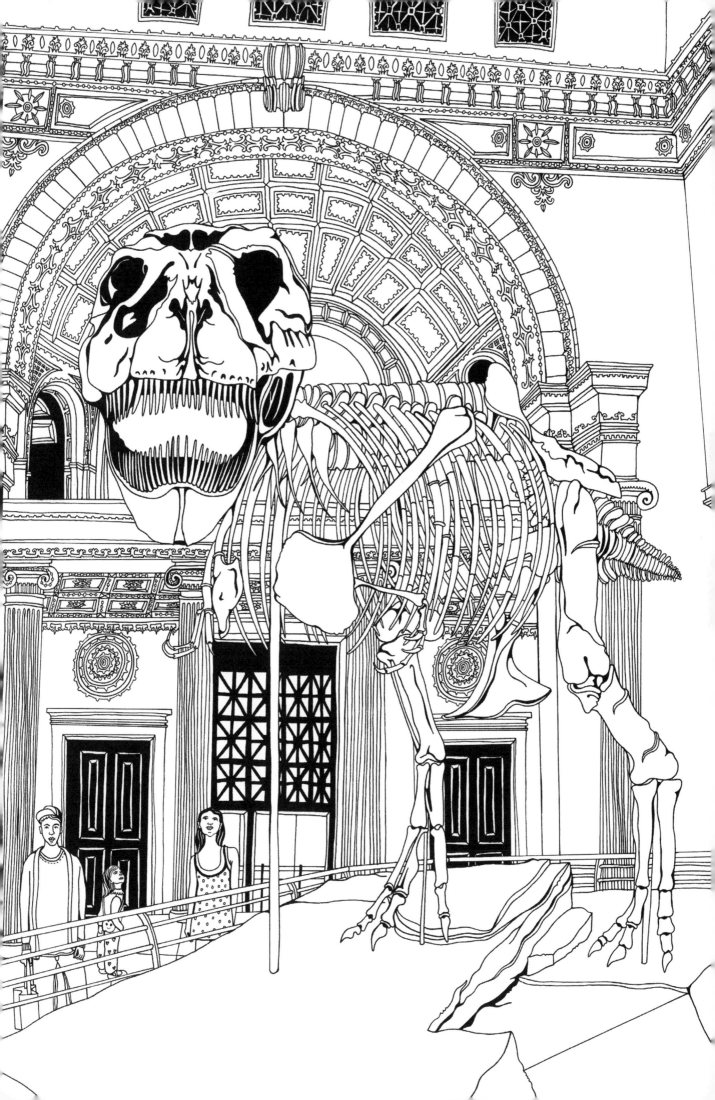

previous page

19.

SUE THE T. REX
AT THE FIELD MUSEUM

Sue, the *Tyrannosaurus rex* skeleton that forms the awe-inspiring central exhibit in the Stanley Field Hall at the Field Museum, wasn't always a city girl. Sixty-seven million years ago, she roamed the plains of South Dakota, and it was here that her skeleton—the most complete example of *T. rex* ever discovered—was uncovered in 1990 by Sue Hendrickson, a commercial fossil hunter, for whom she was eventually named. She took 30,000 hours to put together before being unveiled at the museum. Visitors still shudder at her sharp claws and the fifty-eight razor-sharp teeth gleaming more than twelve feet (over 3.5 m) above their heads.

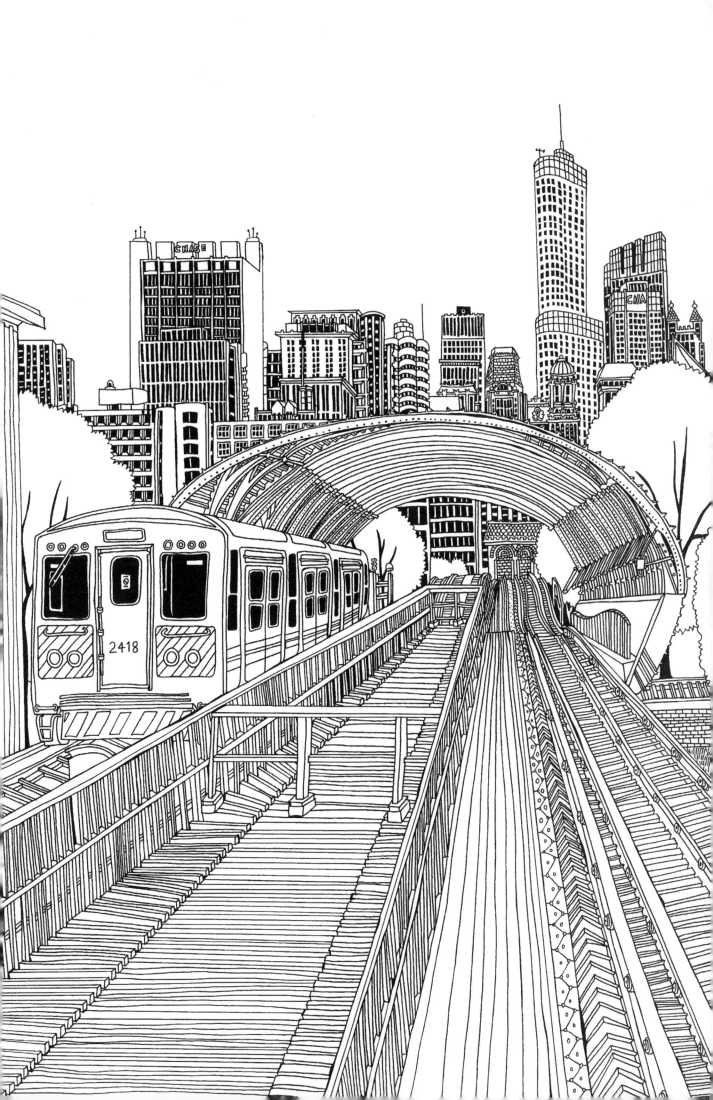

previous page

20.

THE L TRAIN OVER THE McCORMICK TRIBUNE CAMPUS CENTER

It's a challenge to amaze Chicagoans when it comes to architecture: in a city crammed with the best of Frank Lloyd Wright, Mies van der Rohe, and a host of other innovators, they're used to the shock of the new. But the 2003 McCormick Tribune Campus Center, designed by Rem Koolhaas for a challenging site below the L train tracks on the campus of the Illinois Institute of Technology, did raise eyebrows— the tube that Koolhaas used to enclose the L train looks like nothing so much as an outsized piece of rigatoni, squashing the building below. Like all the best architecture though, the tube has a purpose: the L tracks run right over the study building beneath it and the tube deadens the noise of the train overhead. The on-campus nickname for Koolhaas's construction? "Building under the tube": BUTT for short.